The primary aim c learn as to destroy incremental progre These steps are as f

-A child must unlearn his own mind in order to mature.

- All aspects of identity- gender, race, colour and creed are fragile temporary constructs, which paper over the cracks of our true primal core.

- Communication is key, and we should learn to communicate all of our differences away, so that we become one huge blobby grey mass of love and acceptance.

Miriam Elia is headteacher at the London School of Racism, Sexism and Homophobia. She has successfully pioneered schemes of learning which deliberately discriminate against children.

Ezra Elia is a professional kindness instructor, who specialises in infantilising victims of any kind whatsoever.In his spare time, he enjoys collecting beer mats and immigrants, which he hangs in the windows of his North London home.

M.Elia and E.Elia both maintain a strict policy of no contact with anyone that they disagree with.

In undermining everything that the child understands to be true, Dung Beetle advances its core principle of *development through total annihilation of self-worth*, so helping to create the next generation of kind, loving and utterly brainless intellectual elites.

KEY SUBTEXTS is a new experimental scheme exclusive to Dung Beetle Books, where children are given stepping stones to the interior meaning of a surface text. These come in the form of three key words, each of which give a clue to the authors' deeply sinister intent. Eventually your children will learn to confuse insight with paranoia, and so develop a healthy, progressive outlook.

This book belongs to:

Book 1c

THE DUNG BEETLE NEW
WORDS READING SCHEME

We go out

by
M. ELIA and E. ELIA
with illustrations by
M. ELIA

Dung Beetle Ltd © 2016
Printed in Poland by Polish people who fully endorse British values.

We are going out.

"Where are we going?" asks Susan.

"Nowhere," says Mummy, "the journey is the goal."

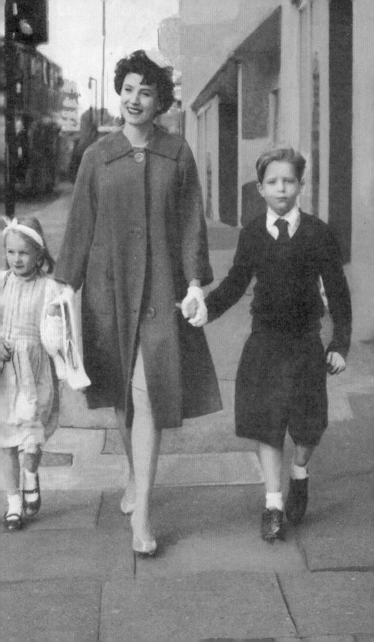

The Orphanage is a luxury development.

"Where are all the children now?" asks John.

"Outside the M25," says Mummy.

THE
ORPHANAGE
Exclusive luxury flats

"Those buildings are tall," says John.

"They are the steel penises of our oppressors," says Mummy.

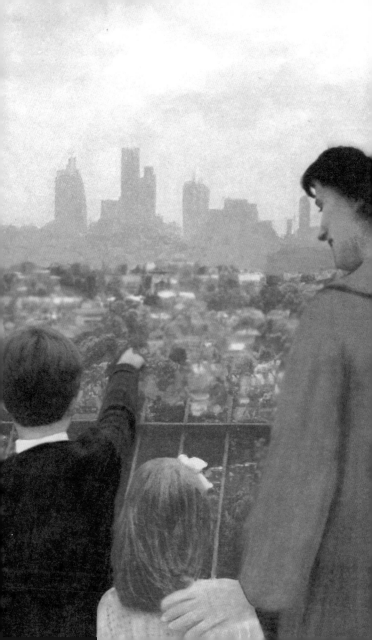

"Good morning," says Mr Nausherwani, "would you like some ripe mangoes?"

"I'm not a racist!" says Mummy.

new words awkward Imperial fruit

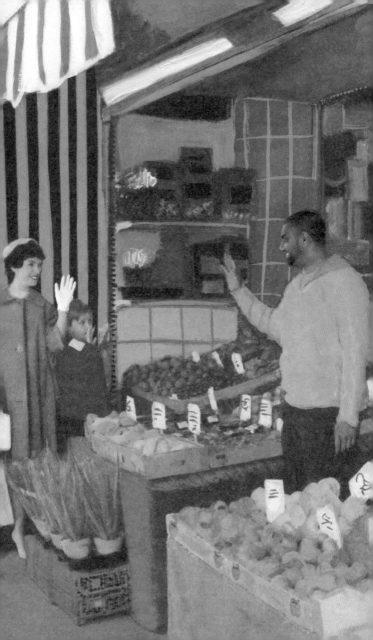

The cupcakes are very tasty.

"All the ingredients are responsibly sourced," says Mummy.

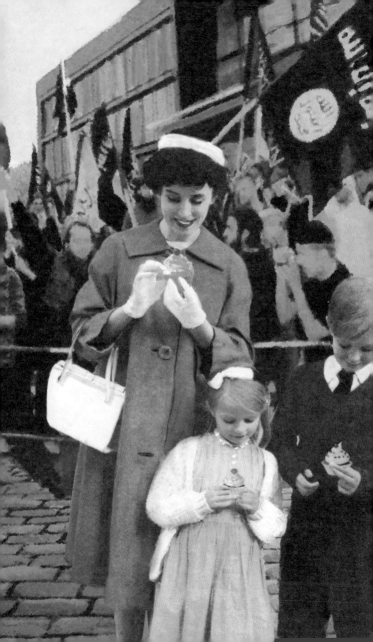

The homeless man is on the bench.

"Give him a blanket," says Mummy, "and then tweet about it to all of your friends."

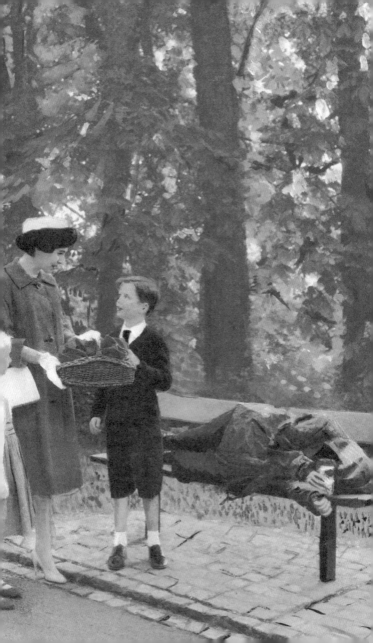

"I don't want to use the ladies' toilet," says John.

"You must explore your feminine side," says Mummy

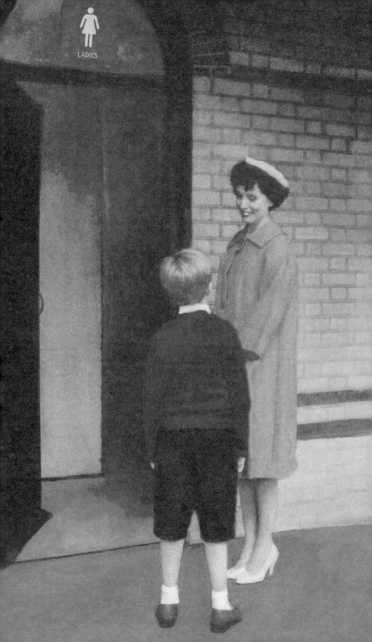

We are going on the boats.

"You can be the refugees, and I will tow you back to Libya," says Mummy.

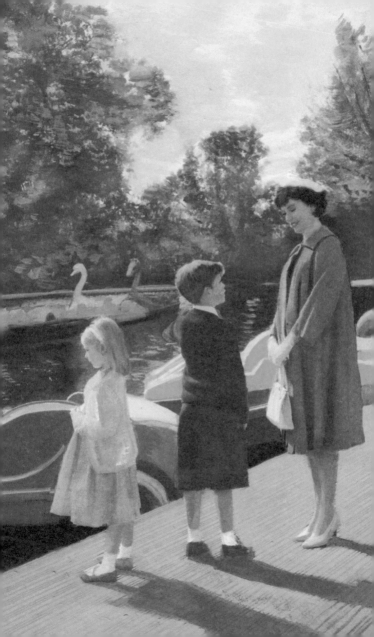

"This shop sells vital goods to the underprivileged," says Mummy.

"Can we go inside?" asks Susan.

"No," says Mummy, "it is all junk."

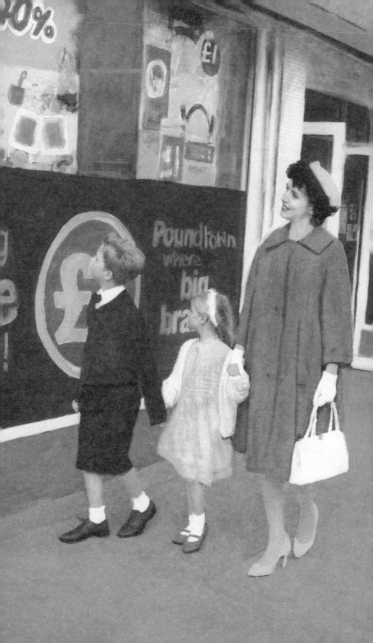

The property is small.

The property is expensive.

Mummy is sad for the poor people.

Mummy is happy because she has made two million on her investment.

new words prosecco guilt club

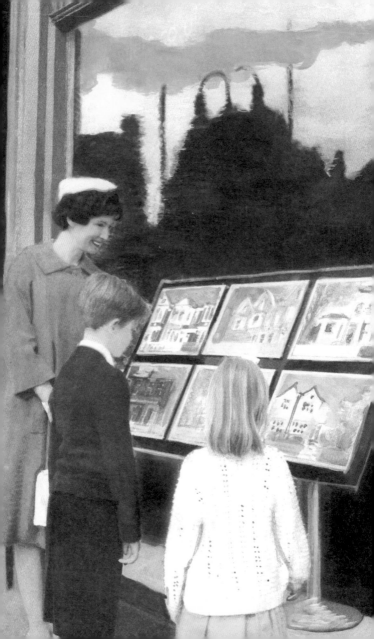

"What does the sculpture mean?" asks Mummy.

"It is a doughnut," says Susan.

"It is a space ship," says John.

"It is the arsehole of modernity," says Mummy.

new words just your interpretation

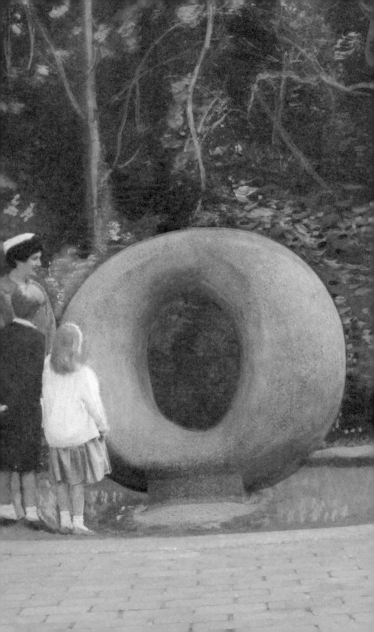

"I want some chicken," says John.

"You want obesity, diabetes and an early grave," says Mummy.

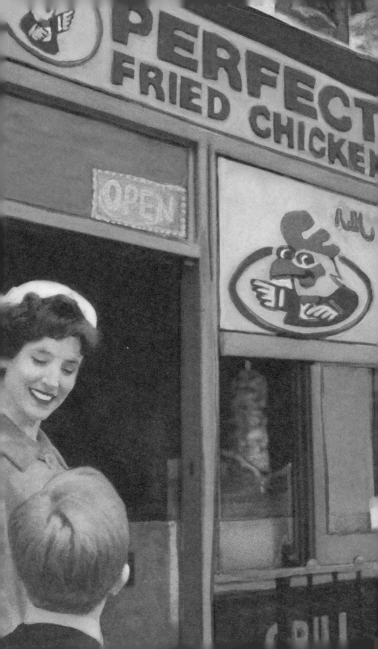

"Can I be a stripper?" asks Susan.

"Yes," says Mummy, "as an ironic gesture."

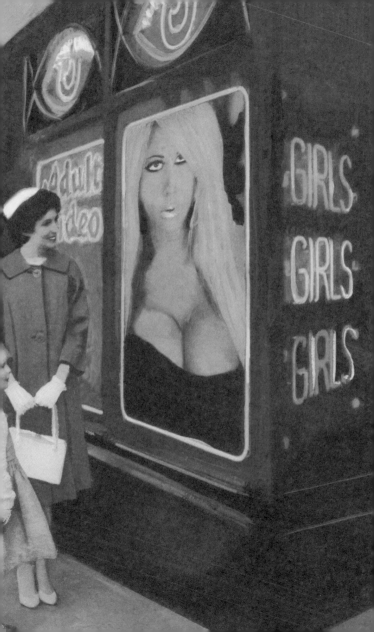

"Will we ever meet Daddy?" asks Susan.

"This is your Daddy," says Mummy.

new words lucrative divorce settlement

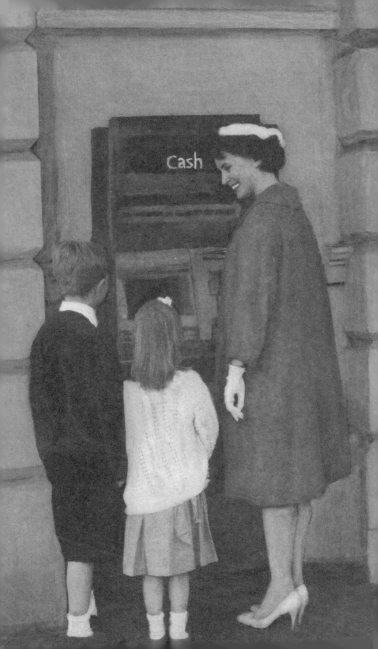

"I want the sword!"
says John.

"I want the baby doll!"
says Susan.

"Welcome to the
gender gulag," says
Mummy.

new words plastic sex construct

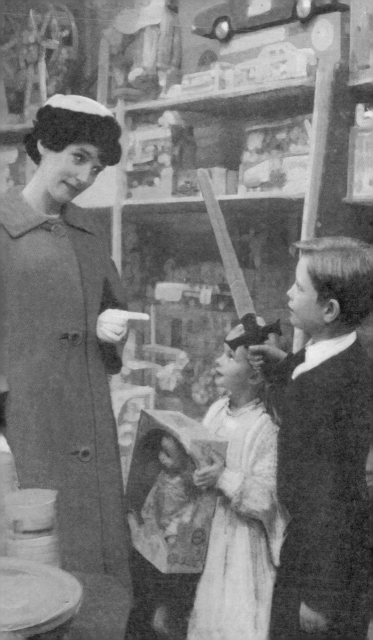

The graffiti is on the wall.

"It is a rebellion against conformity, to which you must conform," says Mummy.

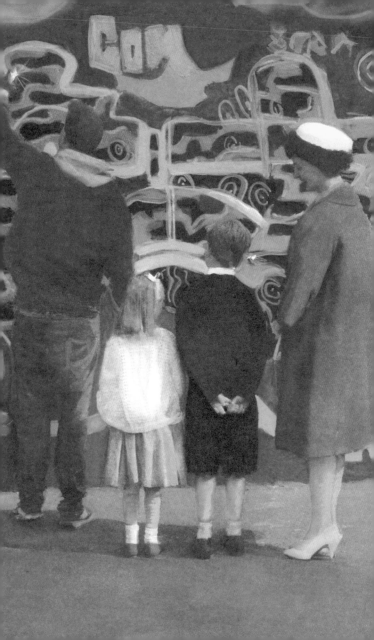

There are the youth.

"They are the avengers of the oppressed," says Mummy.

"They are stealing our car," says Susan.

"I am calling the police," says Mummy.

new words teenage break down

"Is that like our school?" asks Susan.

"Yes" says Mummy, "but with loud music, drugs and lots of sex."

new words beats rhymes dementia

"I want to borrow a Ladybird book," says Susan.

"Ladybird is a sub division of an evil mega corporation who screw over artists and sell watered down rubbish to the general public," says Mummy.

"Does that mean no?" asks Susan.

"Did you enjoy the journey?"asks Mummy.

"Yes," says Susan.

"Yes," says John.

"Good. Now you can complete your doctoral theses," says Mummy.

new words overbearing parental expectation

New words used in this book

6 Cheap/ mindful/ bollocks

8 Vintage/ misery/ realty

10 Global/ financial/ masturbation

12 Awkward/ Imperial/ fruit

14 Ignore/ obvious/ threat

16 Blanket/ vanity/ parade

18 Penis/ vagina/ crisis

20 Pedal/ for/ peace

22 Capitalist/ tack/ fart

24 Prosecco/ guilt/ club

26 Just/ your/ interpretation

28 Trans/ fatty/ apocalypse

30 Mega/ brainy/ boobies

32 Lucrative/ divorce/ settlement

34 Plastic/ sex/ construct

36 Trivial/ anarchy/ fetish

38 Teenage/ break/ down

40 Beats/ rhymes/ dementia

42 Penguin/ not/ funny

44 Overbearing/ parental/ expectations

Total number of new words 60

Dedicated to the big mummy in the sky.

First published 2016 ©